CONTEMPORARY AMERICAN MARINE ART

American Society of Marine Artists

and the

Frye Art Museum, Seattle

in association with the

University of Washington Press,

Seattle and London

1997

Cover: THOMAS HOYNE ———————————— *Rivals*, 1987, 30 x 40 inches, Oil

The late Tom Hoyne (1923-1989) whose art is depicted on the cover, was an active and important Fellow of the American Society of Marine Artists. As a well-trained illustrator of marine art, he took his vast knowledge to the canvas. Tom's wide public acceptance and the great esteem in which he was held by the art world will forever enshrine his work for the enjoyment of future generations.

Rivals depicts the rivalry of steam versus sail. The McManus–designed *Esperanto,* from Gloucester, was built at the Tarr & James yard in Essex in 1906. During her fifteen–year life, she served under many captains and went saltbanking, shacking, halibuting, cod fishing, dory handlining and seining. She was also known for her sailing prowess. Under skipper Marty Welch, *Esperanto* defeated the Canadian *Delawana* in 1920, winning the Dennison Cup in the first International Fishermen's Race off Halifax, Nova Scotia.

The steam trawler *Spray* was built in 1904-05 by the Quincy Fore Shipbuilding Company for the Bay State Fishing Company of Boston. The *Spray* was so successful that eight other similar vessels were built within the following eight years. She served as a tug working out of New York in the early 1920s but returned to Boston in 1928, where she was renamed the *Patrick J. O'Hara* and fished until being broken up in 1943.

Contemporary American Marine Art
The Eleventh National Exhibition of the American Society of Marine Artists

Participating institutions

Frye Art Museum
Seattle, Washington
July 4 – September 14, 1997

Cummer Museum of Art & Gardens
Jacksonville, Florida
November 20, 1997 – February 28, 1998

Exhibition coordination with the Frye Art Museum: William Stevens
Exhibition coordination with the Cummer Museum of Art & Gardens: Peter E. Egeli
Catalogue coordination: William Stevens and Leonard Mizerek

Catalogue editor: Richard V. West
Calalogue design: N. Zaslavsky, Ultragraphics, Los Angeles, CA 90292
Catalogue distribution: University of Washington Press, P.O. Box 50096, Seattle, WA 98145
Printed in Hong Kong

Library of Congress Cataloging-in-Publication Data
Contemporary American marine art : [an exhibition] .
p. cm.
ISBN 0-295-97656-X
1. Marine art, American—Exhibitions. 2. Marine art—20th century—United States—Exhibitions.
I. American Society of Marine Artists. II. Charles and Emma Frye Art Museum.
N8230.C66 1997 760'.04437'0973074797772—dc21 97-15275 CIP

FOREWORD

ARTISTS HAVE BEEN FASCINATED BY THE SEA AND SHIPS SINCE TIME IMMEMORIAL. Even a cursory examination of the art created since ancient times turns up hundreds of examples that demonstrate this lively interest. Although the purpose for early marine depictions such as Egyptian funerary wall paintings or Greek vase decorations was not primarily artistic, the maker's obvious delight in portraying the sea and the complex beauty of ships often surpassed the mere utility of the images they portrayed.

In more recent times as painting grew into a powerful expressive medium, images of the sea and ships have provided us with numerous metaphors, dramas, and meditations. Think how the Dutch and Flemish painters of the seventeenth century used the depictions of horrific shipwrecks to turn our thoughts to the frailty and uncertainty of life. At the same time, think how those artists *enjoyed* painting crashing waves, scudding clouds, and ships breaking up on the rocks of an unfriendly lee shore. Closer in time and space, think of the utter calm and tranquility we find in the nineteenth century marines of the American artist Fitz Hugh Lane, the ships and sea bathed in an enveloping, luminous golden light. These are transcendental meditations on par with the writings of Emerson and Thoreau. Then again, think how clearly and knowledgeably Lane describes the lines, the sheer, and the rigging of those ships, as well as capturing the feel of the sea.

The combination of artistic instinct and "sea legs" is the crucial paradigm in modern marine painting or sculpture. Without artistic instinct, marine art becomes hackneyed, dull, and dry: accuracy without artistry. Without knowledge, experience, and the love of things nautical, the essential "rightness" of the artwork is lost and much of its impact is diffused.

The enormous upheavals in the visual arts during the twentieth century have created real challenges for contemporary marine artists. How can they stay true to the paradigm and yet stretch it to embrace the fundamental changes that have taken place and will continue to occur in the arts? Some of the responses to that challenge are illustrated in this publication. Some artists have looked to the past to recreate the style and feel of previous generations. Others have incorporated elements from artistic movements ranging from impressionism to expressionism to push the limits of the paradigm as far as it will go. Despite a wide diversity in styles and approaches, all these artists are united in striving to communicate through their work the almost primal joy and delight that Walt Whitman also expressed in *Song for All Seas, All Ships:*

> Behold, the sea itself,
> And on its limitless, heaving breast, the ships;
> See, where their white sails, bellying in the wind, speckle the green and the blue,
> See, the steamers coming and going, steaming in and out of port,
> See, dusky and undulating, the long pennants of smoke.
> Behold, the sea itself,
> And on its limitless, heaving breast, the ships.

We are pleased to work with the American Society of Marine Artists in presenting their Eleventh Annual National Exhibition. We congratulate the artists selected for the exhibition and thank them for sharing their visions of seas and ships with us.

Richard V. West, *Executive Director* Dr. Kahren J. Arbitman, *Executive Director*

Frye Art Museum, Seattle, Washington Cummer Museum of Art & Gardens, Jacksonville, Florida

Introduction

IN 1979, A SMALL GROUP OF ARTISTS GATHERED TOGETHER TO FORM THE AMERICAN SOCIETY of Marine Artists, a platform to "... recognize, encourage and promote marine art and maritime history." Offering the opportunity for all interested parties, artists and non-artists alike, to come together in their love of the sea and its environs, the Society has grown from that small conclave of artists to over 600 presently active members.

Marine art has been with us since man's efforts to record images, be it a tiny cave in some far off distant country or on the mighty canvases installed in the world's finest art museums. The Eleventh National Exhibition of the American Society of Marine Artists offers the opportunity for you to view the finest examples of contemporary American marine art being created today. Varied in interpretation, technique, and theme, the exhibition reflects a respect of marine art tradition. The paintings and sculpture speak to us in a variety of ways, causing each of us to respond differently. No matter the medium or style, the works—serenely quiet one moment, ferocious the next—will rivet your attention, hold your interest, and draw you into the world created by the artist. The power of the sea has drawn together a group of men and women as varied in their works as in their other careers. Many have served, or are currently in the navy or merchant marine, while others have been intimately involved in the sailing or construction of their own vessels. Many of them spend as much time on the water as they do painting it.

Some works you see today will eventually become part of a private or museum collection. The relationship of the artist and the sea is destined to endure as it has from the beginning. New eyes will view the sea, apply paint to canvas and capture its eternal beauty and mystery.

This publication reproduces one work by every artist represented in the exhibition accompanied by a statement provided by the artist. The Society trusts that this volume will have a special place in your art collection and will give you an opportunity to relive and refresh your feelings as you stood and, for whatever personal reason, lost yourself in a work of art somewhere in time.

Robert C. Semler, President
American Society of Marine Artists

A Word About the American Society of Marine Artists

The American Society of Marine Artists (ASMA) is a non-profit tax-exempt organization the purpose of which is to recognize and promote marine art and maritime history and to encourage cooperation among artists, historians, marine enthusiasts and others engaged in activities relating to marine art and maritime history.

With members in forty states, the Society has compiled an impressive record and is widely respected by the art community, galleries, maritime museums, marine and naval enthusiasts, as well as collectors and art critics. ASMA welcomes as members everyone interested in marine art, the history of marine art, and our rich maritime heritage.

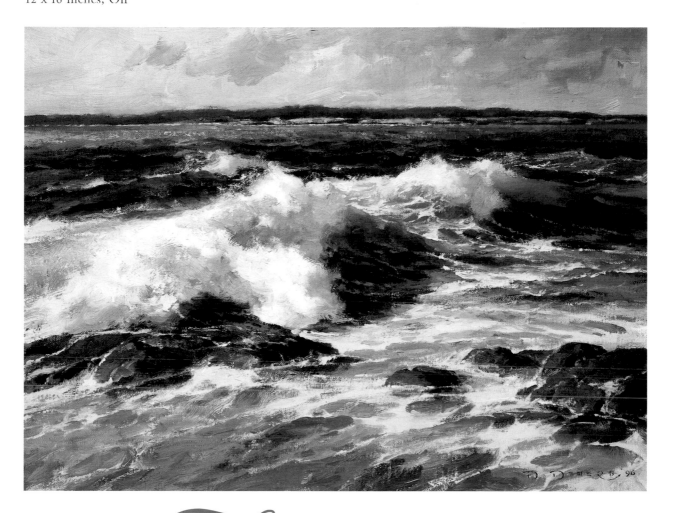

MY WORK AS A PAINTER FALLS INTO TWO BASIC DISCIPLINES. One is that of representational documentary work, usually historic in subject. The other deals with more pure painting issues such as direct observation and using visual memory. Many of my paintings become a hybrid of both of these approaches or methods. The first approach lends itself to narrative while the second deals with more immediate visual and emotional issues.

The painting illustrated here is of the second kind. The first stages of this painting were conceived and executed from direct observation on location. Later, it was developed in the studio from memory. The kinetic nature of water demands an archetypal understanding of its many characters and principles, so that those characteristics may be used by the artist for visual or aesthetic intentions.

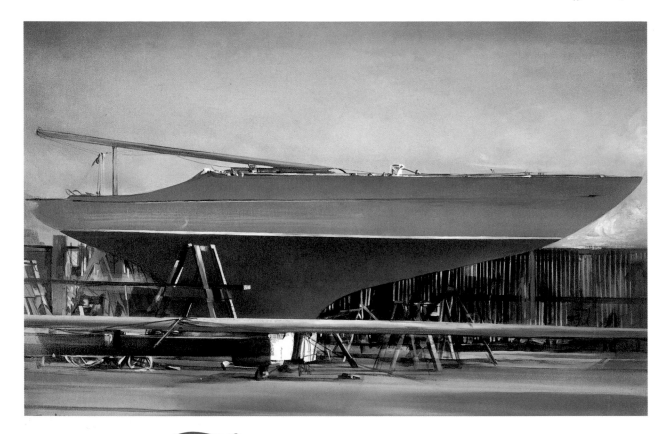

*P*OLLY REPRESENTS ONE OF THE MOST FAMOUS DESIGNS
of the Alden firm: number 157, known as the Bird Class of San Francisco
Bay. The result of a collaboration between Alden and F. C. Brewer, a naval
architect from Sausalito, the first boat was built for Brewer in 1922. Stability and excellence in
heavy weather were hallmarks of this design, due in part to its solid construction.

My husband owned *Polly* for fourteen years, heading out into the bracing San
Francisco Bay winds every weekend. Out of respect for her age, he didn't race her but, out of
shape as she was, she had the heart of a true competitor. Under four hundred square feet of sail
we had to hold her down, lest she do herself mischief. We picnicked on Angel Island or spent
weekends in the Sacramento-San Joaquin Delta, ice chests stowed under the low supporting
beams of the deck, sleeping bags tucked up on her two little wooden bunks. Passing ships never
failed to call out "what a beautiful sailboat!" We never tired of it, and neither did *Polly*.

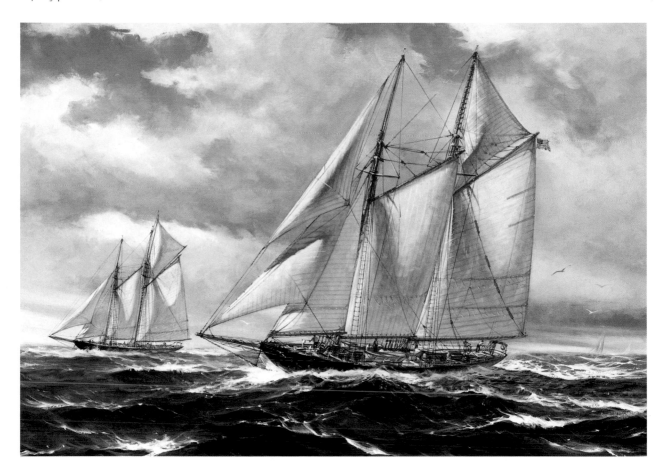

THIS SCENE SHOWS TWO LARGE SAILING VESSELS OFF
San Francisco. *Vega* is in the foreground; the ship to starboard is *Zaca*. Built in
Germany, *Vega* (named after the star) is a 135 foot steel schooner designed for
ocean racing. Before WW II *Vega* was owned by H.W. Rohl, the Long Beach, California, tug
and barge tycoon. *Zaca* (an Indian name for peace) was built for Tempelton Crockett, the San
Francisco banker and railroad man. He used the vessel for long voyages to the South Pacific.

Both vessels were aquired by the U.S. Navy during WW II as air-sea rescue ships,
sailing between San Francisco and Hawaii. I was assigned to *Vega* as communications officer
during the summer of 1944.

WILLIAM G. MULLER

Night-Docking, South Street, New York, 1895, 1996

20 x 30 inches, Oil, Collection of Richard and Diana Hastings

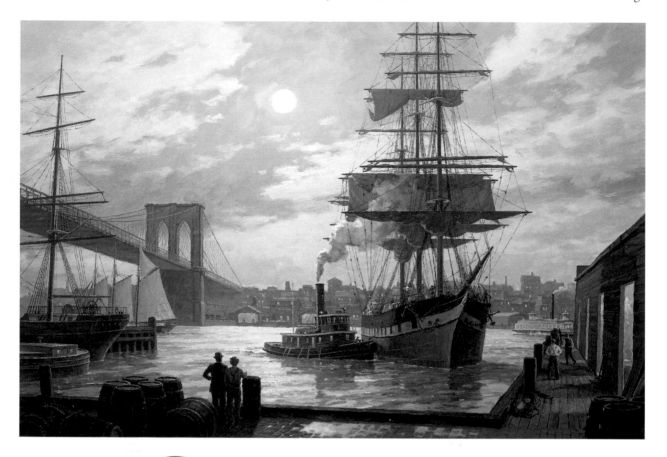

THE SQUARE-RIGGED SHIP *WAVERTREE* IS SHOWN BEING EASED by a steam tugboat into an East River slip along Manhattan's busy South Street waterfront on a calm, moonlit early night in 1895. Across the river is Brooklyn with the Brooklyn Bridge to the left. The South Street piers were the gathering places for the big ships from abroad that brought valuable cargoes to nourish the ever-growing city and beyond. Today, the 1885 vintage *Wavertree* is preserved at the South Street Seaport Museum in New York. Much of my inspiration for becoming a maritime historical painter came from my early exposure to the then bustling Port of New York in the 1940s. Having since witnessed the dramatic decline in shipping and the ending of the colorful steam era in the port, I now find myself primarily drawn to recapturing more satisfying subject matter: the beauty, romance and atmosphere of our turn-of-the-century ships and harbors.

15¾ x 25¾ inches, Acrylic

HAVING OFF-LOADED HER CARGO OF LIQUID AMMONIA to a customer on the North East Cape Fear River, the *Bowspring* is riding high and ready to be turned for her return trip down river. Two tugs of Cape Fear Towing, the *Fort Jackson* on the bow and the *Fort Caswell* pulling amidships, have the assignment of turning the *Bowspring*, a considerable task this day considering the strong northeast winds.

Paula G. Waterman

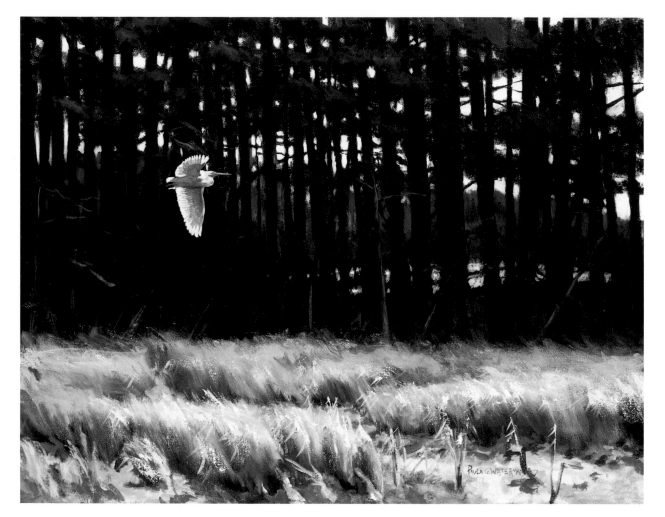

*B*EFORE I STARTED WORKING IN OILS IN 1996, MY MAIN medium was drawing on black and white scratchboard. Painting in oils is a liberating experience for me because the medium allows shapes to be suggested with large brushstrokes. Changes and corrections are easy in oils, an advantage not present in my drawing medium! My favored subjects have always been marine birds. This Great Egret is flying over Blackwater National Wildlife Refuge in late November.

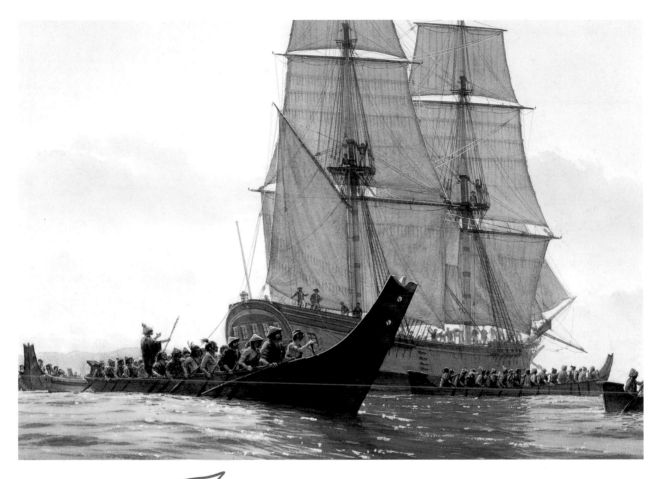

JOHN MEARE'S SNOW, *FELICE ADVENTURER,* WAS AN EARLY
participant in the Northwest fur trade. When running down the coast near
Cape Flattery, her men became alarmed by the arrival of a large contingent of
Makahs, fearsome looking and threatening in their canoes. The tension was broken when
the warriors, circling the ship, suddenly burst into a song of welcome. The title comes from
Meares' description of the scene in his *Voyages...to the North West Coast of America.*

KONRAD HANSALIK

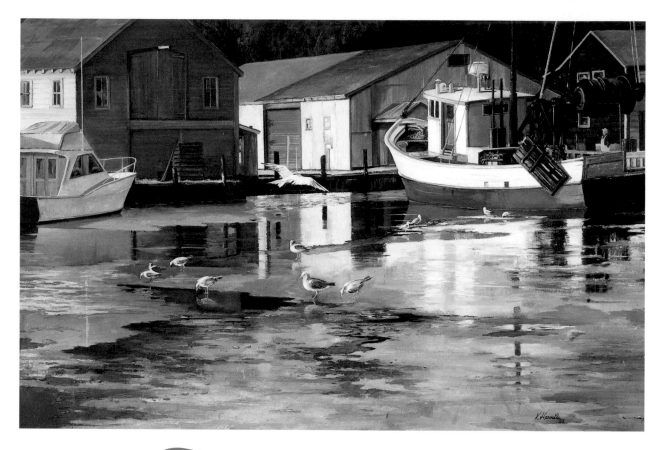

THE LIGHT AND ATMOSPHERIC EFFECTS VIEWED AT THIS LONG
Island harbor during the winter season have been an inspiration for at least two of
my recent paintings. Orowock Creek is just down the road from my Islip home
of twenty-five years and is familiar territory.

I prefer to begin my waterfront paintings with a thin veil of color over a toned ground.
This approach helps establish the subtle and unifying color relationships so important in creat-
ing the visual expression and atmosphere of the waterfront. Several black and white composition
sketches were initially made on paper using charcoal pencil. One of these was selected to serve
as a point of departure for the painting. I then blocked in my underpainting, concentrating on
three or four basic values. The best light for both paintings was just before sundown, since
reflections and shadow patterns seemed to be most pronounced at that time. A "Z" pattern was
chosen in this painting to direct the eye from the foreground to the background while
maintaining the center of interest within the composition.

THIS IS A VIEW OF THE FISHING SCHOONER *ARTHUR JAMES* leaving Gloucester at sunrise with a blustery northwest wind just after the turn of the century. Built in 1905, she was one of the high liners of the Mackerel Fleet. Around her, the fleet prepares to get underway. With a full load of salt and one seine boat on deck and another towing astern, the *Arthur James* is bound south to meet the schools of mackerel off the Carolina Capes.

As John Connolly wrote in *The Seiners,* "I don't suppose that Gloucester Harbor will ever again look as beautiful to me as it did that morning when we sailed out. Forty sail of seiners leaving within two hours, and to see them going—to see them one after another loose sails and up with them, break out anchors, pay off, and away!"

CHRISTOPHER BARTLETT

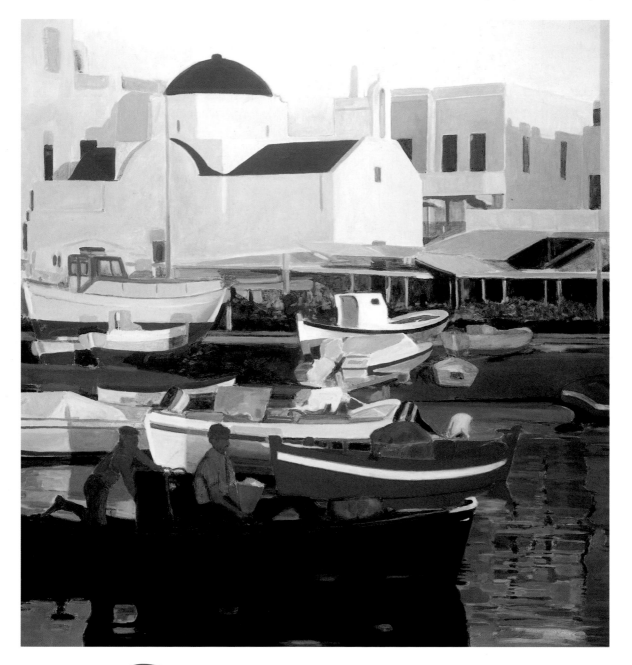

*T*HE HARBOR AT MYKONOS IS USUALLY FULL OF LIFE BUT AS THE sun set it was infused with a tranquil warm light, creating a harmony of glowing colors. Subject matter is a springboard for an investigation into sets of relationships using a personal aesthetic vocabulary. Coastal imagery provides an endless variety of possibilities in arranging and re-arranging these relationships, recombining visual data into a more visually satisfying whole.

I PAINTED THIS SCENE ON LOCATION, WHILE VACATIONING in Sicily. These sturdy fishing boats are typical and can be seen on many of the island's waterways. Some have been pulled up on shore; some tied to ancient moorings, and others abandoned where they lay. There are so many, it is as if everyone has one of his own—yet, each boat has its own personality in the way it is painted or by the objects placed inside.

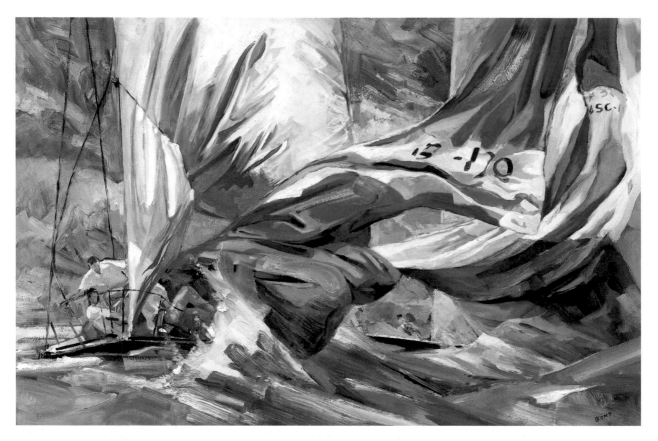

*A*CTION AT THE MARK. THIS BOAT MAY NOT BE LEADING
the fleet long considering the condition of the wayward spinnaker.

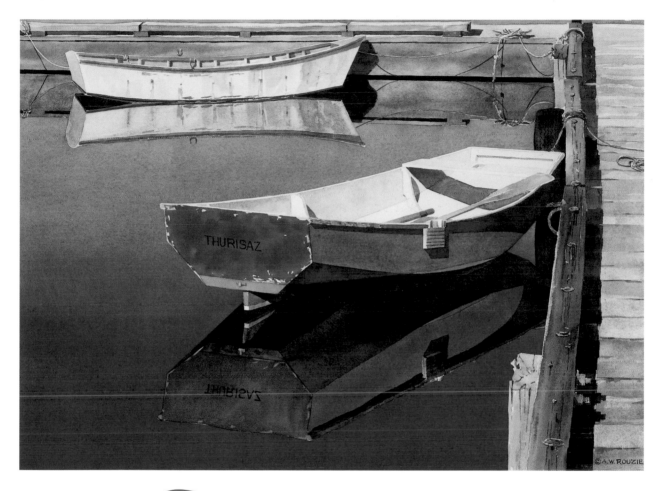

THE MARINA AT FRIDAY HARBOR, WASHINGTON, IS PROBABLY THE biggest and busiest in the San Juan Islands, and in mid-summer it accommodates an impressive variety of elegant yachts. But off in the quiet corners of this complex of floats and boats one can sometimes find more humble craft. *Thurisaz*—small, simple, but perky and colorful—seemed to say "I am the quintessential boat!" Floating like a leaf on a quiet pond, she waits patiently at the dock, perhaps to transport an owner to a more grandiose vessel, or perhaps to take him on a snappy sail around the harbor—if he brings the sail.

CAROL RAYBIN

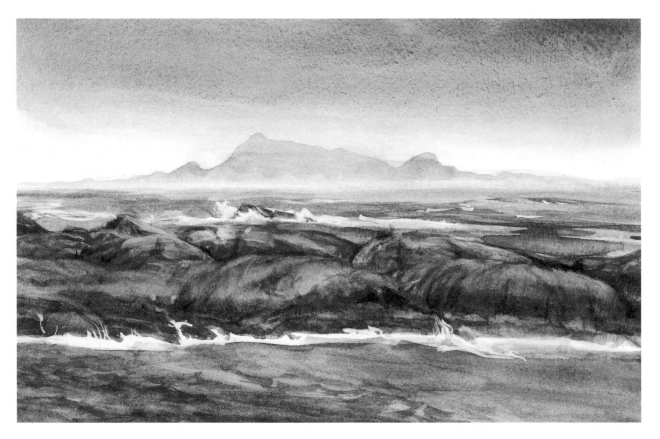

*T*HIS WATERCOLOR WAS PAINTED ON LOCATION IN NORWAY'S
Lofoten Islands, 150 miles north of the Arctic Circle. I tried to capture the
atmosphere of this gray, windswept landscape of barrier rocks, sea and fog.
The rapidly changing weather conditions and unusual light found on these islands, as well
as the power of the sea, inspired my attempt to paint the calm before the storm.

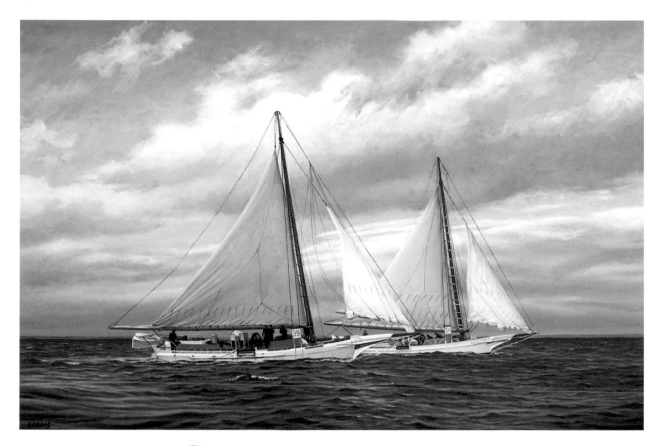

SKIPJACKS ARE AN OVERBUILT, SHALLOW DRAFT, CENTER BOARD sailboat, developed to pull oyster dredges in the shoal water where oysters thrive, primarily in Maryland's Chesapeake Bay. Another asset of the boat is that it requires only a small crew. In skipjack jargon, "taking a lick" means to cross an oyster bar with dredges overboard. When oysters and skipjacks were plentiful, one could watch the boats weaving their endless patterns back and forth over the oyster beds.

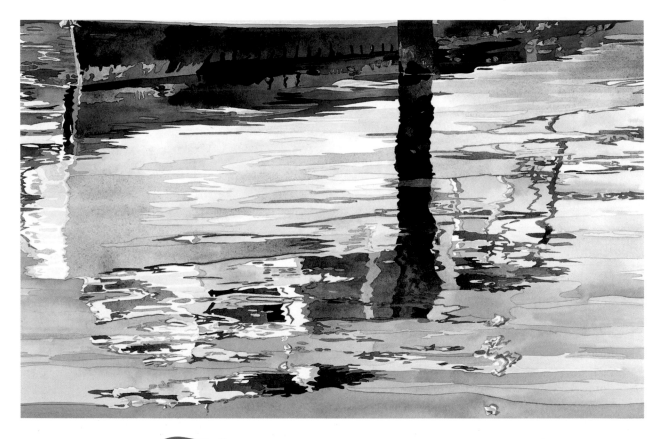

THE TITLE REFERS TO THE DATE OF COMPLETION. THE PAINTING is part of a series I call the *Waterline Set*. The subjects of the series are intensely detailed observations of the waterline (boot top) of deadrise workboats. Deadrise workboats were made famous by their Chesapeake representatives. In this instance, I used the detailed reflection to describe the workboat. While rendered in true detail, the composition speaks to the deeper, more abstract relationship I have with the subject.

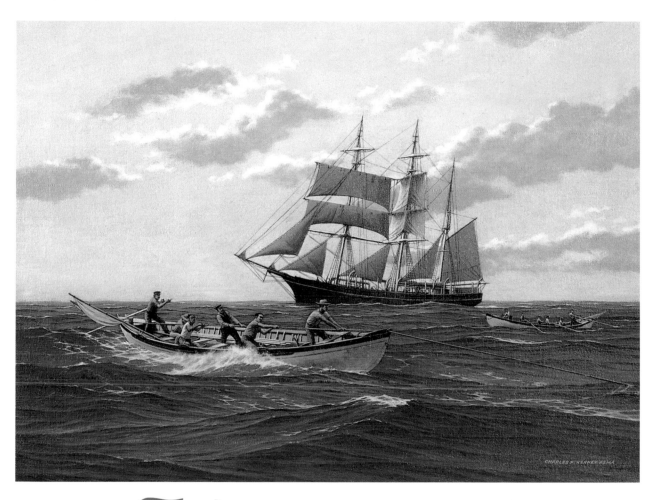

WHALING IN THE NINETEENTH CENTURY WAS A FAR CRY FROM the greedy mechanized industry which followed it. The early whale cruise lasted up to three years, during which time the whaleman had to endure long periods of boredom at sea while searching for a pod of whales. He existed with bad food, sickness, and poor pay in the effort to provide his country with whale oil—the principal source of illumination prior to the use of petroleum and electricity. The painting depicts a whaleboat already secured to a harpooned whale and being towed at high speed, perhaps out of sight of the mother ship. This event was called the "Nantucket Sleigh Ride."

JEANNE ROCKETT

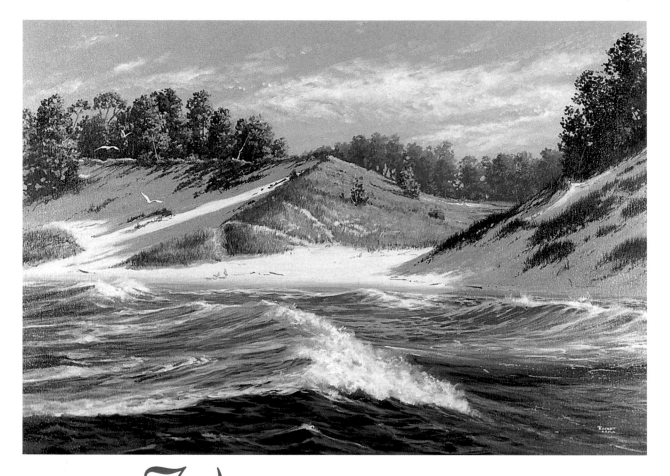

*Y*OU PAINT BEST WHAT YOU LOVE BEST. MY EARLIEST MEMORIES of happy times were those spent at Lake Michigan, "The Big Lake." I played with family and friends in the reddish-gold sands, so different from ocean beaches. I bravely stood as cold, crashing waves banged against me, and screamed with excitement. I remember waking up every morning wondering what the lake would be like and going to sleep every night to the rhythm of the washing waves, which carried through the sand to our cottage sited safely on a cliff reached by forty steps. *You paint best what you know best.* I've never left the region of "The Big Lake." Now, more than ever, I treasure its diversity as I focus the subject of my paintings on its constantly changing beauty, an endless subject for a life-long body of work.

16¾ x 9 x 9 inches, Bronze

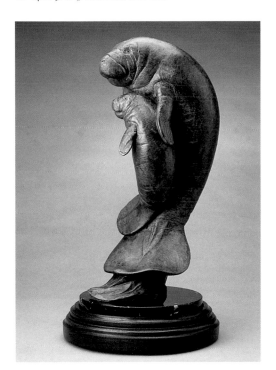

*M*ANATEES, OR SEACOWS, ARE LARGE WATER mammals that nurse their young, belonging to the order of *sirenia.* Sailors of old, supposedly mistaking them for mermaids, originated the scientific name. Today it might be hard to imagine them as irresistible maidens, the sirens of legends, to lure sailors on the rocks, but for a sculptor they are beautiful subjects. Rather than sack-like and shapeless as often represented, they are full of sculptural forms. Without a thick layer of blubber under the skin, their muscles and bones are clearly visible after study, defining their sculptural subtleties. In this country, manatees are best known as residents of Florida, but last fall one individual strayed from Mexico to pay a visit in Corpus Christi Bay, Texas, near Padre Island where I live. Manatees are threatened throughout their range, and are in danger of extinction.

RENEE HEADINGS

Companions, 1996

12 x 9 x 15, Bronze

I HAVE BECOME VERY ATTACHED to dolphins, after spending many hours watching them in their natural habitat. They have a bond that one can sense, and I have tried to capture that closeness in this sculpture. Since they are constantly crisscrossing around each other, I created a design that would personify their movements but that would also show their playfulness.

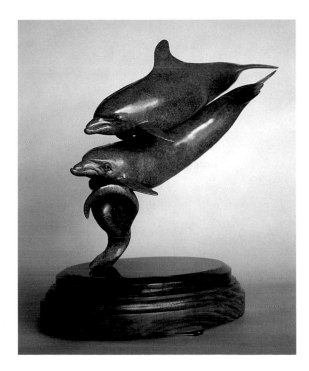

CHARLES F. WHITE

Pioneer, 1991

9¾ x 14½ inches, Watercolor

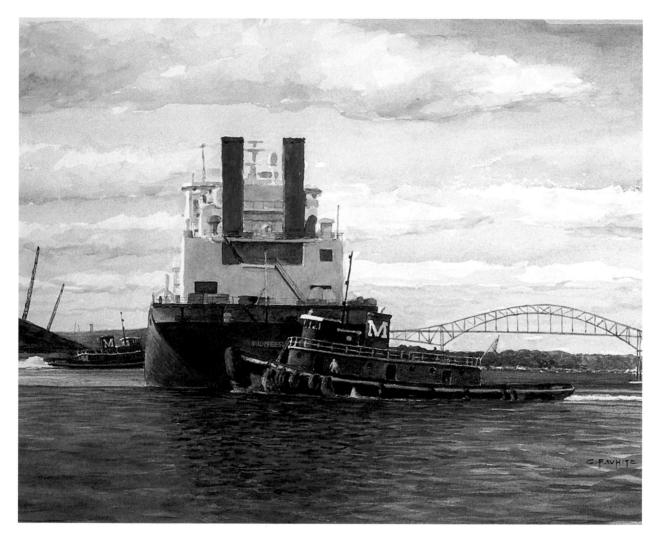

THIS PAINTING DEPICTS THE TANKER *PIONEER* BEING MANEUVERED into position by two Moran tugs in Portsmouth, New Hampshire. This harbor can become a very busy place when a large ship comes in. I happened to be there at the time to observe and photograph much of the activity. In this painting, I tried to bring to the viewer some of the feelings of movement and action that I felt that day in Portsmouth.

CHARLES R. ROBINSON

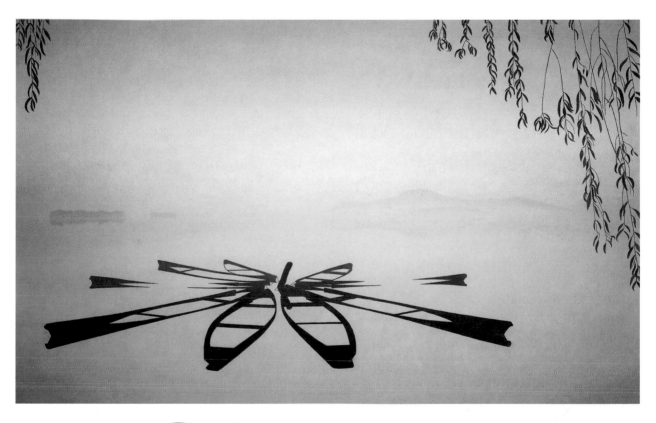

*A*LTHOUGH THE ARTIST SPENT MORE THAN A MONTH traveling extensively in China earlier this decade, he was surprised to see how throughly the Cultural Revolution destroyed the arts, temples and architecture of ancient China. Nevertheless, he found in the lakes of the ancient capital, Hangzhou, the simple beauty of an everyday scene—a peaceful abstraction unaffected by the throes of that revolution.

Here, under the boughs of a weeping willow on the bank, a series of gondola–like boats, which are used to take Chinese tourists about the lakes, lie moored by the bows. It had rained heavily the night before, so the boats were partially or completely swamped. The result is a semi-abstract, starlike apparition emerging from the mist of early dawn.

DON MCMICHAEL

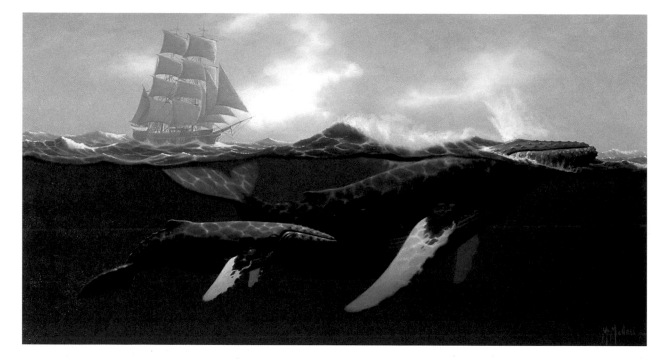

WHILE CRUISING THE WHALING GROUNDS LOOKING FOR THIER prey, a a whaling ship sights a blow down wind. The pursuit begins, but as soon as it begins the wind picks up and the visibility starts to close. After a short period of time, the chase is called off and the humpback whale cow and calf go on their journey while the whaler rides out the blow and waits for better weather.

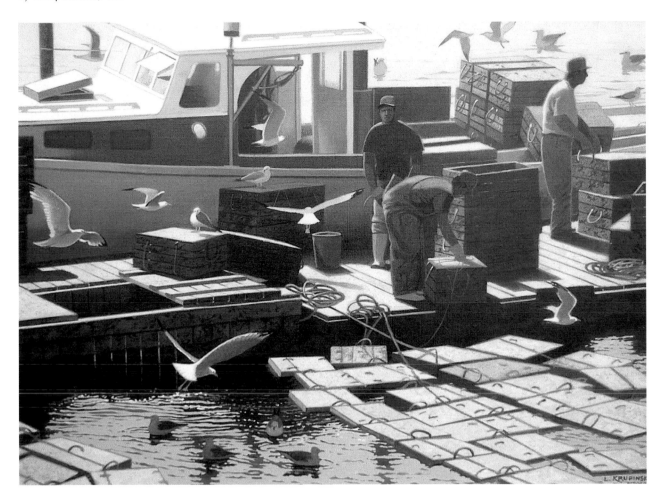

CARVERS HARBOR IS LOCATED ON VINALHAVEN ISLAND in Penobscot Bay, Maine. Lobstering is its primary business. The lobster boats far outnumber the pleasure boats. Floating fish houses and docks are in abundance as are gulls waiting for a free lunch. Lobsters are placed in a holding pen in crates called lobster cars. The "cars" are then loaded in the stern of the boats waiting to deliver them across the bay to a Rockland lobster pound.

ANN BRODIE HILL

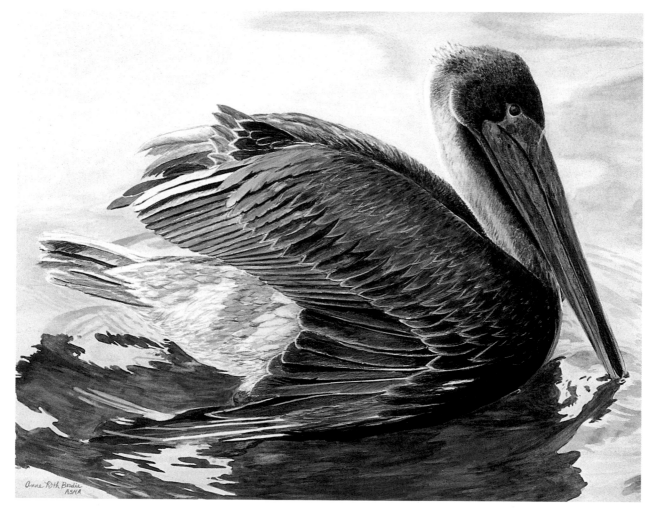

WHILE IN FLORIDA, I WAS GLAD TO SEE THE NUMBER OF pelicans increasing, and this young brown pelican appeared especially proud to be back.

Sunset View from the Steamboat Hotel–Buffalo Harbor 1868, 1995 ——————— RAYMOND MASSEY

17 x 24 inches, Oil

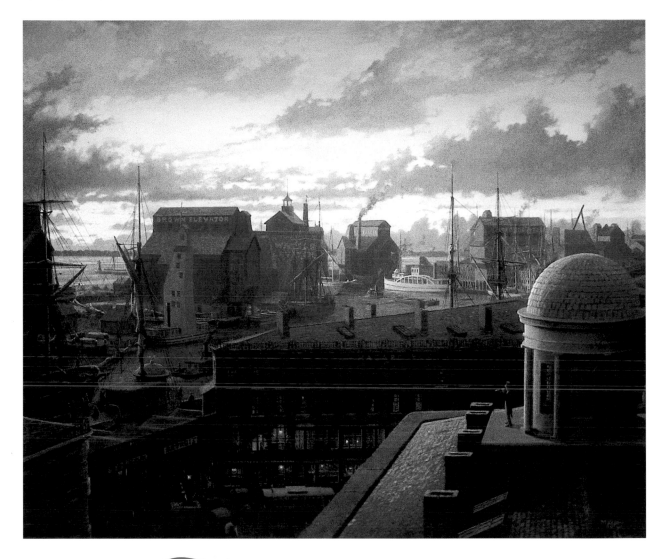

T HIS PAINTING DEPICTS A VIEW OVERLOOKING LOWER MAIN
Street in Buffalo where the Hazard Block building framed the busy pedestrian
traffic at both the street and elevated boardwalk levels. Travelers to Toledo,
Detroit, and ports west are seen entering the arch for the dock where passengers could board
steamboats. The Hazard, Brown, Watson, Bennett and Reed grain elevators filter the early
sunset light onto the shipping canal. The original Buffalo lighthouse stands at the distant harbor
entrance as you view the Canadian shore of Lake Erie in the background. The unusual cupola
in the foreground capped the Steamboat Hotel and gave this building an impressive vantage
point from which to look out over Buffalo's bustling grain milling port. By 1868, Buffalo was
the largest grain milling city in the world and truly the Queen City of the Great Lakes.

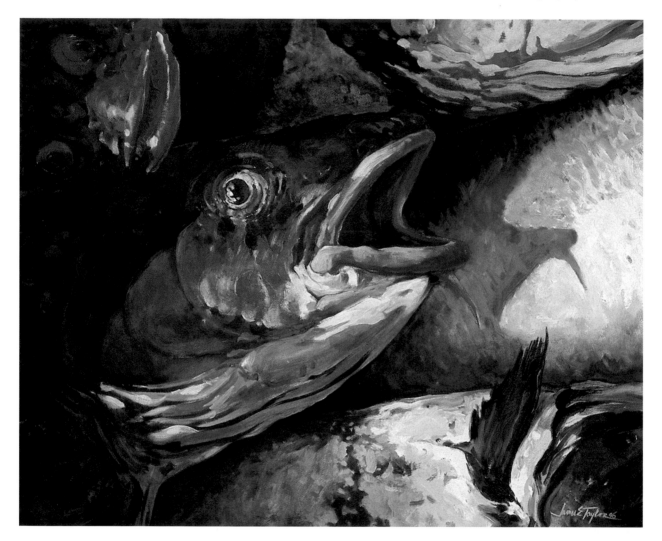

FOLKLORE SAYS THAT SCULPIN ARE NOT SUPPOSED TO BE edible. As it dies it turns bright red, so the first time you land one you will wonder in dismay: has someone played a joke on you? I certainly don't think I would enjoy the meal, although the presentation in this age of new edible species and gourmet delights has possibilities: on a bed of fresh spinach perhaps? But would you take the first bite? The familiar cod is another bottom feeder and has fed people everywhere for centuries. When you hook into a cod it feels like you snagged a rock. Bringing the cod to the surface is like lifting weights. The cod does not look like a colorful fish, but while the fish is wet it is still very colorful.

Waterways Fisherman, 1995

12 x 30 inches, Acrylic

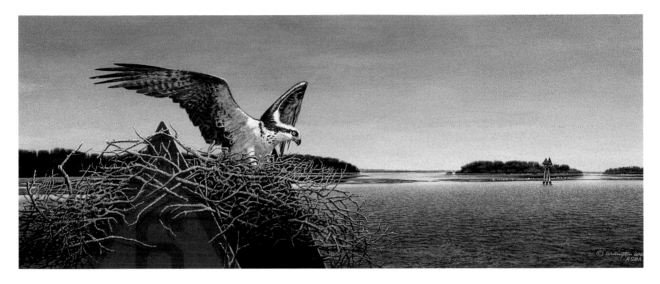

I HAVE ALWAYS SKETCHED AND TAKEN PHOTOS ALONG THE inter-coastal waterway where I live. My studio home in Florida overlooks a small bay where Osprey by the dozens do what they do best; dive for fish from great heights. Without fail, many of the fish hawks use channel markers: too convenient for them to resist and too interesting for me not to paint.

MICHAEL KILLELEA

Coney Island Light, 1996

13 x 19 inches, Oil

W INTER SUNSETS CAN paint things with a striking palette. This lighthouse is one of a series of Long Island lighthouses I'm working on. This unusual Coast Guard light is tucked in among the brick houses of Seagate, a community at the extreme western end of Coney Island, and serves as a marker for ships approaching the Verrazano Bridge. I've shown it as the last brilliant rays of sunshine break through the clouds.

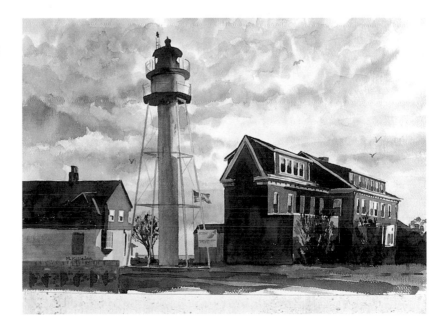

DONALD STOLTENBERG

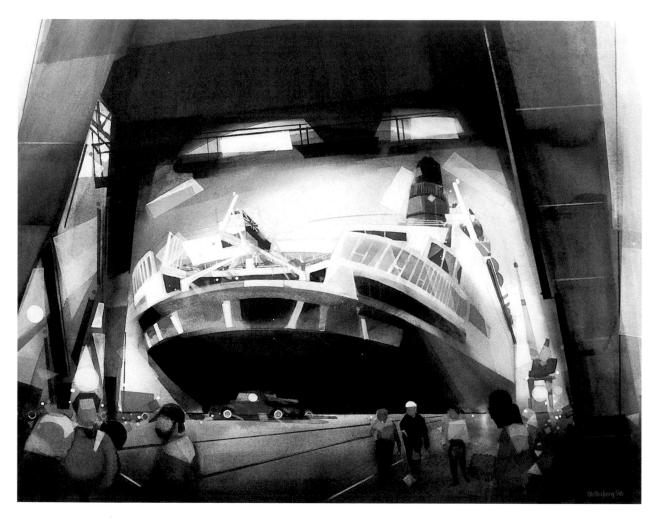

THE CUNARD LINE'S FLAGSHIP RAN AGROUND OFF MARTHA'S
Vineyard in the late summer of 1992 and was taken to the venerable
Commonwealth Drydock in South Boston for temporary repairs. During the time
she was there, thousands of people came to see her in these unfamiliar surroundings. I was
struck by the view of the huge ship as framed by the legs of the dockside traveling crane and
I made sketches and photographs at the time which finally developed into this painting.

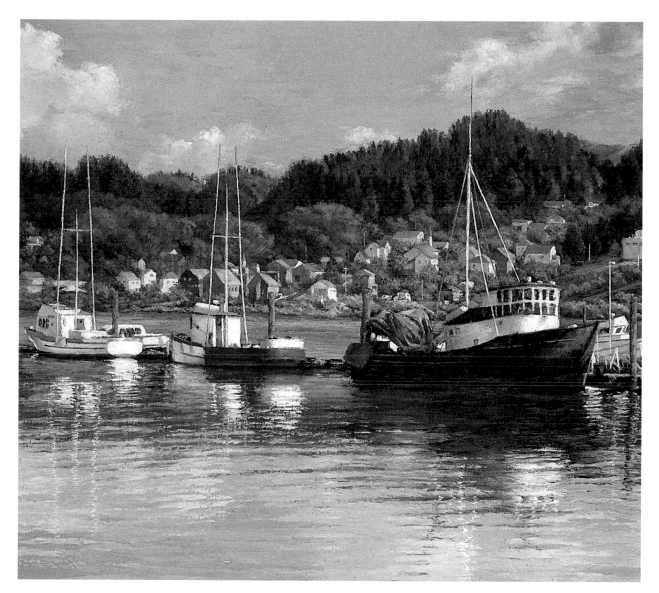

ASTORIA, OREGON IS THE OLDEST SETTLEMENT WEST OF THE
Rockies. Located in a panoramic setting among the hills at the mouth of the
beautiful Columbia River, it was named after John Jacob Astor, who brought
his fur trading company to the area in 1811. It is filled with Victorian homes and lush natural
beauty. Here you can witness the enormous ships from all over the world passing through to
their destination ports of Portland or Longview, Washington. The busy river settlement is also
a favorite port for sport fishermen and a favorite subject of mine for painting.

George F. McWilliams

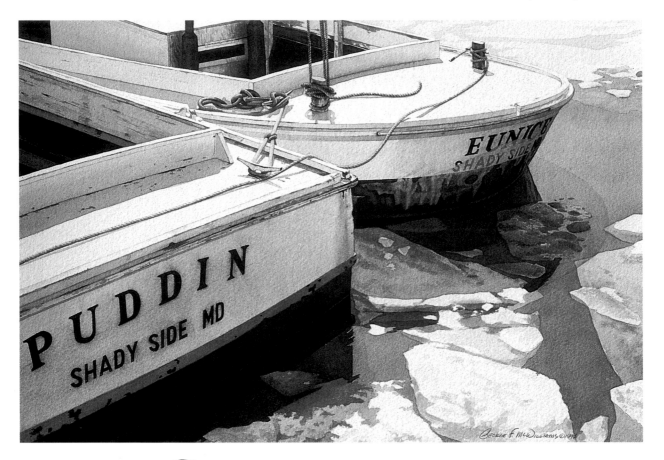

Having grown up around wooden workboats, I have always been fascinated by their design. *Puddin* and *Eunice* are two "patent tong" workboats that I saw frozen in the harbor in Annapolis, Maryland. I don't know what caught my eye first, the names or the difference in stern construction. Both are interesting in their own right but the combination of the two, along with the ice, make a unique composition.

19 x 29 inches, Watercolor

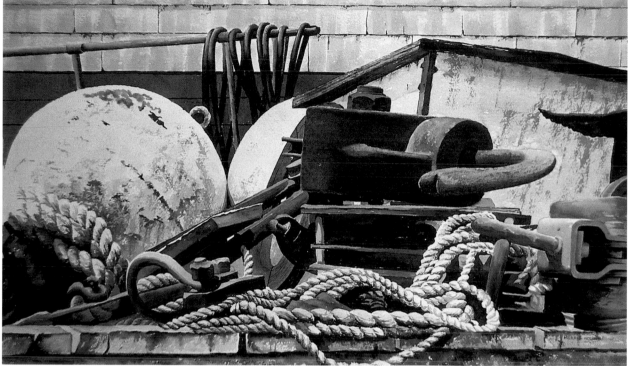

*T*HE OWNERS OF CAPTAIN GEORGE'S TUGS MAKE SURE THAT the boats are painted and polished and repaired. Their docks, however, are a wonderful collection of wornout, rusted, and broken marine paraphernalia. A search along the docks, on a bright sunny day, reveals stark shadows and shapes, which, after years of salty rains, lose their bright blues and greens and become a monochrome study in browns.

James Minnicks

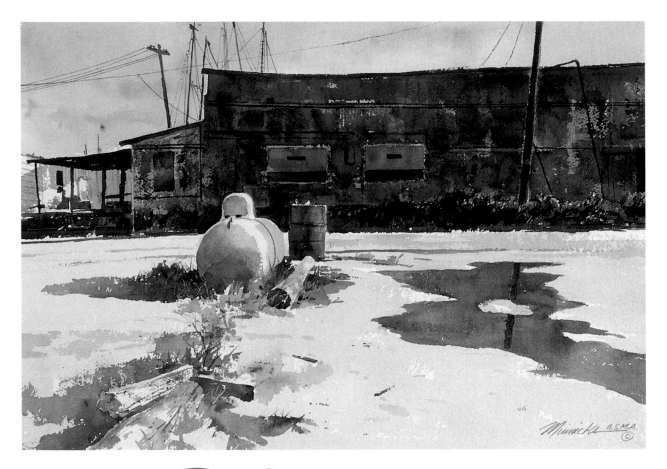

My INTEREST IN MARINE ART STARTED YEARS AGO WITH a vacation trip to Maine with my family. To paint for my own enjoyment rather than do illustrations for commercial use was, and is, a continuing challenge as well as pleasure. The world of working boats, fishermen, docks and harbors has been a constant source of visual variety and excitement for me. I've painted "the waterfront" from southern New Jersey to the Bay of Fundy, as well as Maine and Cape Cod. The history of the sea can be interesting for some, but for me the real world of today's marine activity is more varied, active and colorful.

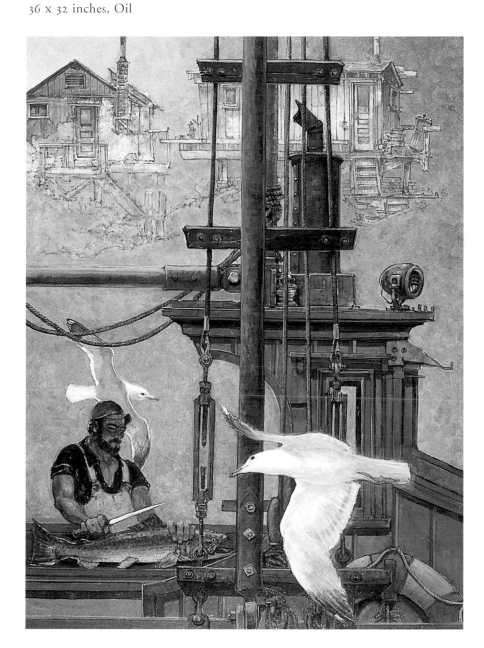

BELOW CHILLIWACK ON THE GREAT FRASER RIVER, ONE CAN
find an assortment of maritime settlements. The seagoing people who reside
in them ply the waters down river to the Straits of Georgia, bringing home
the catch to prepare for market. In the background are the fishermen's cottages, ironically once
owned by Japanese settlers who, during World War II, were forcibly displaced and interned
up river at Lemon Creek. Life on the waterfront of the silent river continues now with no
apparent evidence of these earlier generations.

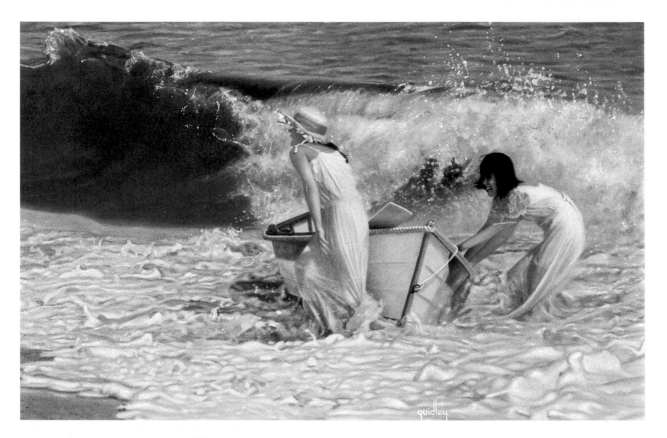

I HAVE LONG WANTED TO CREATE A PAINTING WITH TWO women pushing a skiff into a gentle rolling surf. The concept became a reality one summer when a local boatyard generously lent their beautiful peapod skiff for the afternoon. My wife, son, daughter-in-law, and I carried the heavy skiff down to the Atlantic not realizing the size of the waves or the strong undertow. Despite this, I decided we should try a few different quick photos. Exhausted from the long walk with the boat, my family reluctantly made their way into the water with the skiff. Exhaustion soon turned into laughter as the first wave began to crest. Weak with laughter, the models could not hold the boat, which flipped on top of my son and ended the shoot. The painting is the result of one of the four shots I was able to take before aiding in the recovery of the boat.

Building transparent glazes, I average four to six weeks on a painting. When a piece is near completion I sand it to provide a smooth finish.

4 x 16 inches, Etching and aquatint

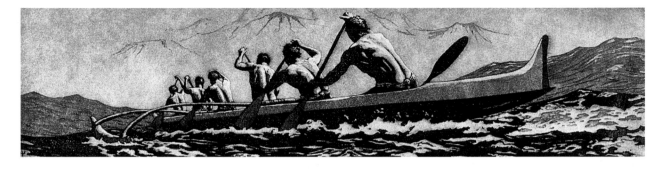

KALOHI IS THE CHANNEL RUNNING BETWEEN MOLOKAI AND LANAI in Hawaii. The canoe trip across the Pailolo channel from Maui makes one feel like a cork while going from crest to trough to crest. The canoe depicted here has entered the Kalohi channel and will shortly be in flatter water.

ROBERT WEISS ——————————————————————— *Herman Melville*, 1996

5⅞ H X 4½ W X 1⅝ D inches, Scrimshaw on antique elephant ivory

THE RENOWNED AUTHOR OF *MOBY DICK*, Herman Melville was born in 1819 in New York City. After working as a bank clerk, a cabin boy, and an elementary school teacher, Melville joined the crew of the Pacific bound whaler *Acushnet* in 1841. Deserting ship in the Marquesa Islands, he made his way to Tahiti and Honolulu, returning as an ordinary seaman on the frigate *United States* to Boston where where he was discharged in 1844. Books based on his adventures won him immediate success, but the complexity of the later *Moby Dick* alienated many readers. As a result, Melville turned exclusively to poetry, which was published in small, privately subsidized editions. From 1866 to 1885, Melville served as a deputy inspector in the New York City Customhouse. He died on September 28, 1891.

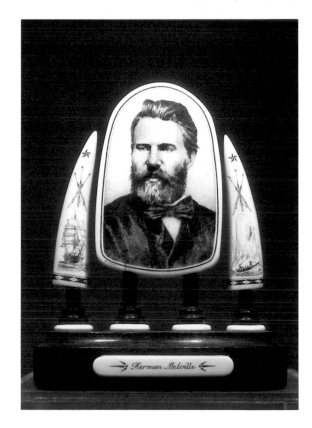

Victor Mays

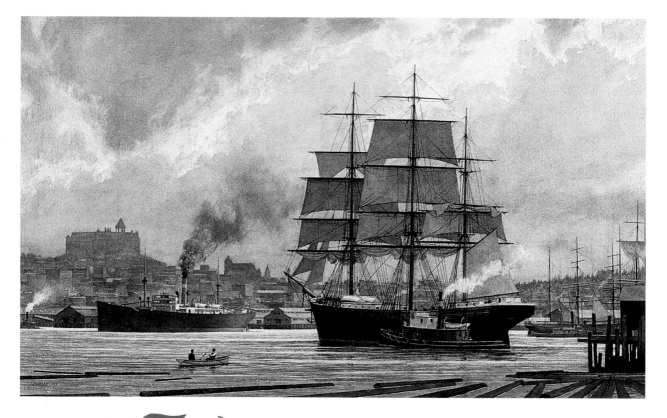

ITH THE AID OF A TUG, A SQUARE-RIGGED DOWNEASTER SLIPS across Elliott Bay toward the piers. Seattle was a lively hub of shipping—sail and steam, coastal and blue water. Maneuvering through a daily bustle of tugs, paddle ferries, launches and yachts, vessels carried away cargoes of lumber, coal, grain and seafood. Crowning the shoreline was the great Washington Hotel on Denny Hill. In 1906, both hotel and hill were pulled down in the massive Denny regrade, the earth and rubble becoming fill to extend the shoreline seaward.

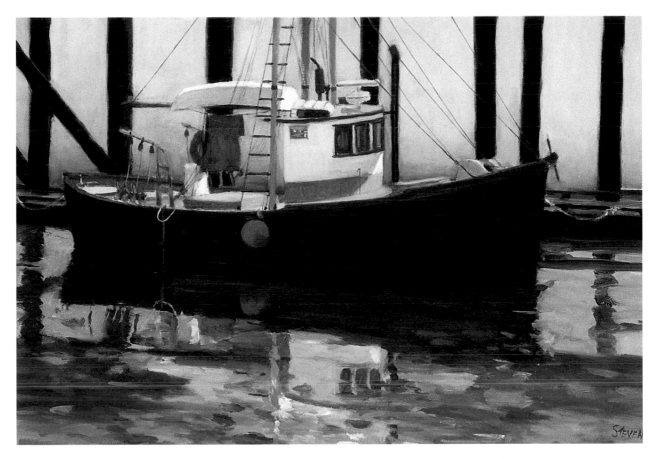

THIS TROLLER REPRESENTS ONE OF THE LAST DOUBLE-ENDED fishing boats operating in the rugged waters off the west coast of Vancouver Island, British Columbia. For many years they were the standard boat for a single fisherman to make his living from the sea. Now time and modernization are retiring these seaworthy little boats.

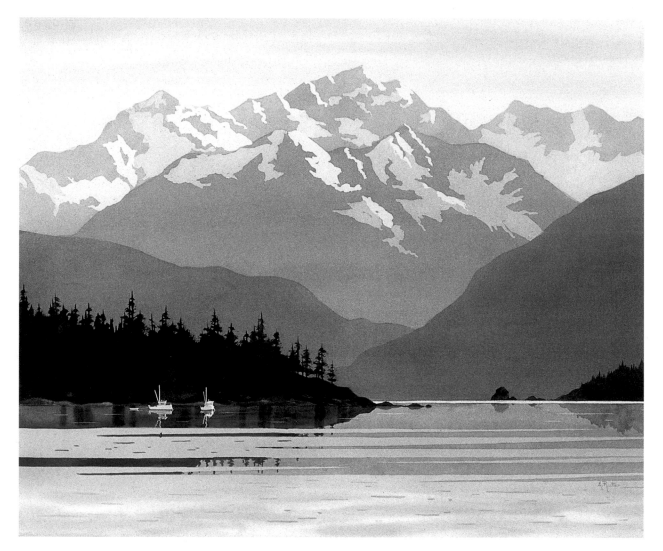

THE CHILKAT RANGE, RISING ABRUPTLY FROM THE CLEAR WATERS of Lynn Canal south of Haines, Alaska, is one of the most ruggedly beautiful of Southeast Alaska. As an artist, I find this area to be most challenging and satisfying to portray. The feeling of vast mountain ranges, contrasted with countless islands and the few small signs of human life, is what I tried to capture in this painting.

HOWARD SCHAFER

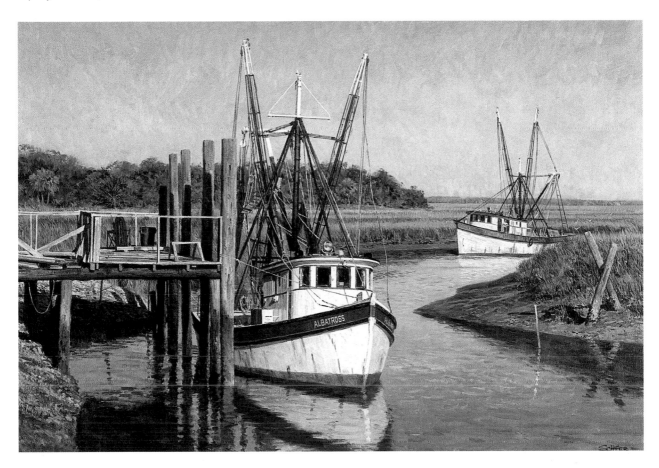

*M*ANY COMMERCIAL FISHING CRAFT DESIGNS HAVE EVOLVED more modern and functional lines, but shrimpers seem to have kept their traditional look. Even the modern ones still have an exaggerated sheer-line and an abundance of gear aloft. I painted these two older wooden boats that were docked up a tidal creek, far from the high class marinas along the inter-coastal waterway.

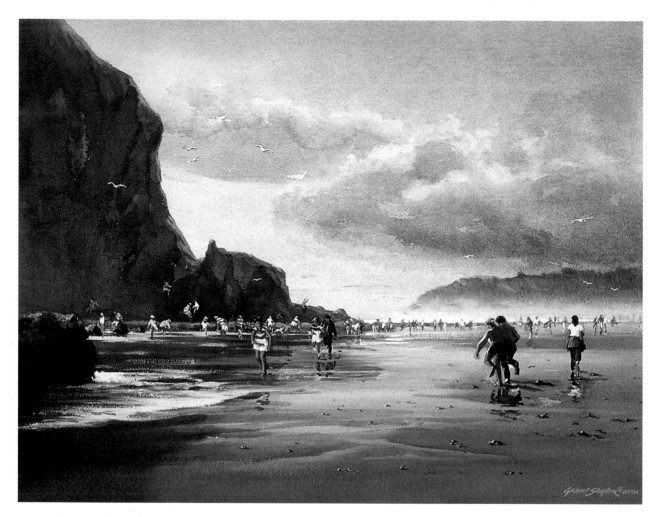

CANNON BEACH, WITH ITS MAGNIFICENT HAYSTACK ROCK, IS IN Oregon and draws people from all three western states on any day, weather permitting. On weekends, hundreds gather with ample room for all to wet their feet in the surf or pilot a sail bike down the firm sand. Winters also attract visitors who want to see the great waves breaking.

PETE PETERSON

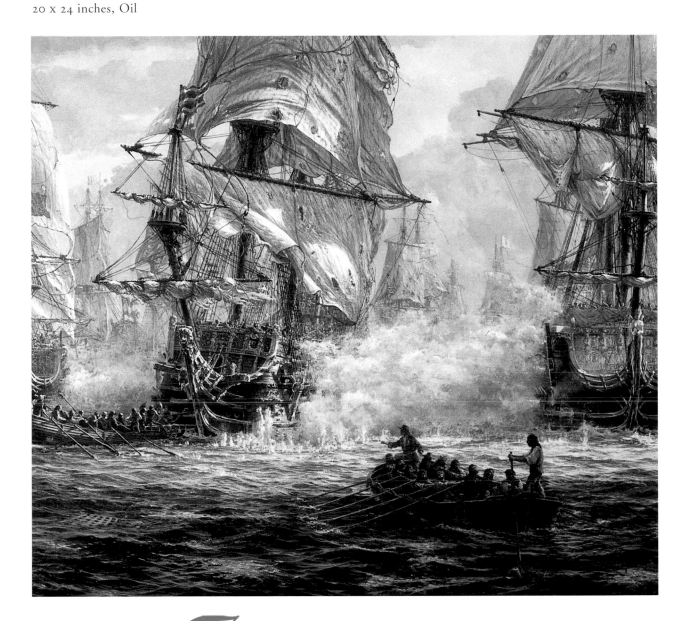

*I*N 1690, ENGLAND AND HOLLAND WERE AT WAR WITH FRANCE. My painting attempts to capture some of the drama of the battle of Beachy Head, a major sea engagement in the English Channel between French ships and a combined English and Dutch fleet. The Dutch engaged first; a fierce battle ensued. The English ships pulled back, leaving the Dutch ships to fend for themselves. In this scene, a large French ship moves slowly past a battered Dutch vessel, firing a broadside at point blank range. Her sails in tatters, dead in the water and leaking badly, the Dutch ship valiantly fires back while her seamen desperately attempt to kedge their vessel out of the line of battle.

JAMES E. MITCHELL

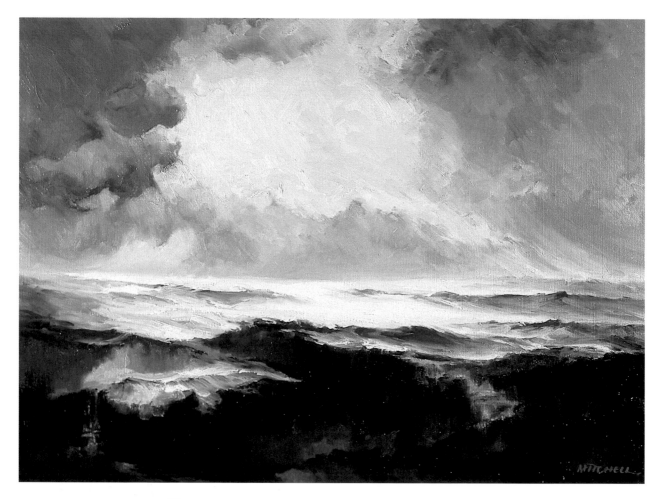

*T*HIS PAINTING IS AMONG THE SERIES OF STUDIES WHICH EVOLVED
from a number of thumbnail sketches that led to more finished pencils and then
larger, finish-size charcoal renderings. From these, I evolved my color studies.
I have always been fascinated with the play of light and color on the forms of the sea and sky.
From the more familiar real, I am continuously breaking down the somewhat limiting elements
of sea and sky into imaginative color and patterns of movement. To my eye, the sea can be far
more than greens or blues, or the reflections of the sky colors. I feel the artist's role is one of
interpretation and experimentation. This is too seldom attemped in the field of marine works.
To do so, however, is to lift the artform out of the eighteenth, nineteenth, and now twentieth
centuries to bring it into the modern era where it can occupy an important niche. I continue
to preach expressionism in my serious easel pantings.

Detail, *Sunset on the Merrimac*, 1995

30 x 40 inches, Oil

PETER ROGERS

DUE TO UNTIMELY SURGERY on the artist's painting arm, neither of his exhibition images, *Immovable Object, Irrestible Force*, and *No Name Northeaster, East Point Nahant, MA*, (1997, 36 x 48 inches, oil) are reproduced in the catalogue. Both paintings depict the perpetual struggle of fluid oceans against the coast line. Shown here is a detail of a previous work.

RICHARD STIERS

Rascals, 1996

Height 36 inches, Bronze

SHEER JOY AND THE SPIRIT OF THREE frolicking sea lions is captured as these creatures engage in a playful game of chase. One seal has found a stray piece of kelp and teases the second. Their playful activity surprises the third, and she joins the pursuit.

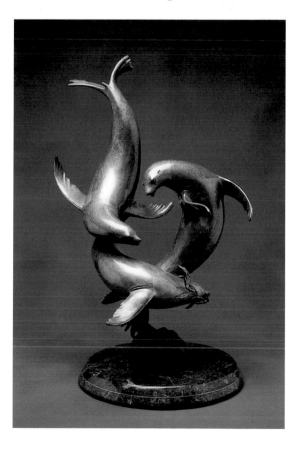

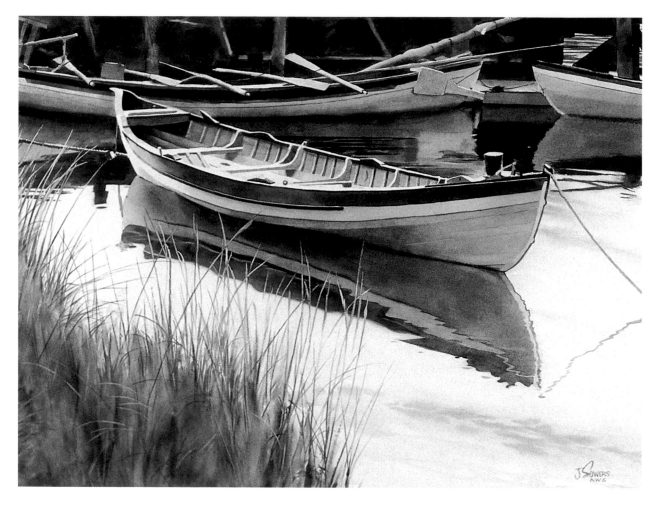

THIS IS A TRANSPARENT WATERCOLOR OF A WHALEBOAT AT Mystic Seaport, Connecticut. I was impressed by this beautiful hand-crafted boat and the mirror-like violet reflection on the yellow glow of the water. The two boats and the oars against the dark pier in the background add an interesting abstract pattern to this painting.

20¼ x 28¾ inches, Pen and ink and watercolor

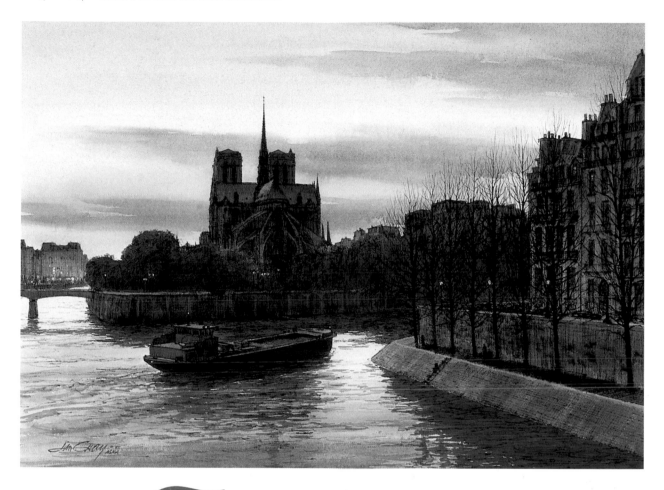

THIS PIECE DEPICTS A BARGE-BOAT LADEN WITH SAND AND GRAVEL making its way between the Ile-de-la-Cité ("Isle of the City") and the Ile-de-St.-Louis ("Isle of St. Louis") in the river Seine. Notre Dame Cathedral is in the background on the Ile-de-la-Cité, the island where the city of Paris was founded.

My wife, Fran, and I lived for a couple of weeks on the Ile-de-St.-Louis and enjoyed strolling to either the Left Bank or the Right Bank of the Seine. Every day was filled with sketching, photographing, walking, eating, and enjoying life in one of the greatest cities in the world.

Alfred Entering Mendocino Bay, 1996

16 x 24 inches, Oil

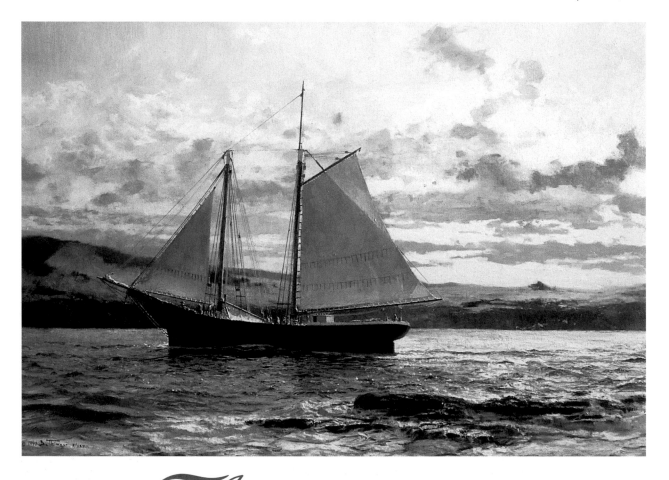

*A*LFRED WAS A TYPICAL EXAMPLE OF THE TYPE OF SCHOONER
built for the lumber trade in the 1860s and 1870s. She registered 96 gross tons
and was built in 1870 by Clarke and Whitehouse at San Francisco.
Such vessels were typically around 100 tons, carried a centerboard, and had no fore topmast.
Alfred was owned by the Mendocino Lumber Company and met her fate the way so many
of them did. She was at her moorings in Mendocino Bay when heavy weather started coming
in from the west and then southwest. This anchorage was one of the better "doghole" ports on
the northern California coast, but was still a dangerous place. The ship's moorings could not
hold her against the force of the storm, so she was driven against the bluffs on the north side
of the bay and was quickly ground into sawdust.

ROGER SALISBURY

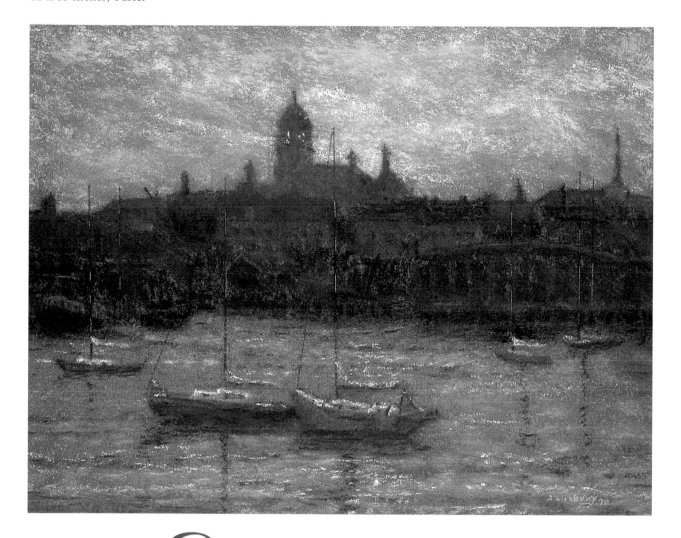

EARLY SUMMER EVENING IS A MAGICAL TIME FOR RECORDING Gloucester Harbor. Little has changed since the artists Fitz Hugh Lane and Winslow Homer made the harbor famous in the nineteenth century. The smog-free light and water casts everything in shimmering elegance. The advantage of pastel as a medium is its immediacy; multiple layers of color were worked over a rough pumice-gesso museum board support.

ROBERT SEMLER

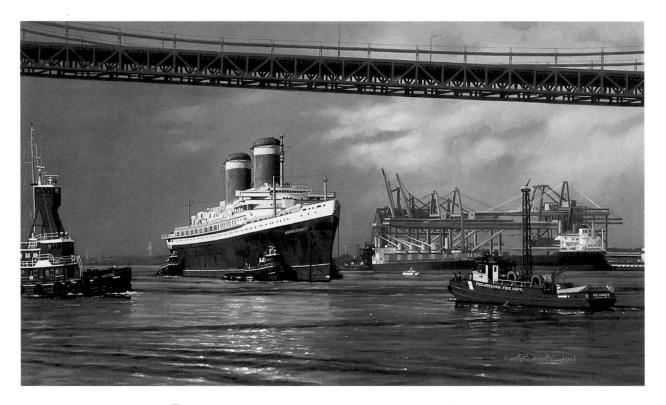

\mathcal{T}HE LUXURY LINER *SS UNITED STATES* IS SHOWN BEING GUIDED under the Walt Whitman Bridge in Philadelphia on August 15, 1996, on her way to a temporary berth at Pier 96 on the Delaware River, in anticipation of what lies in store for her in the future. Will she be eventually restored to her former glory as a cruise ship, perhaps a floating hotel, or will she be ultimately consigned to a salvage yard for scrap metal? As she nears the famous span, guided by tugboats of Moran Towing, the tugboat *Evening Tide,* the Philadelphia fireboat *Delaware,* and a 41 foot Coast Guard patrol boat check the ocean liner's clearances.

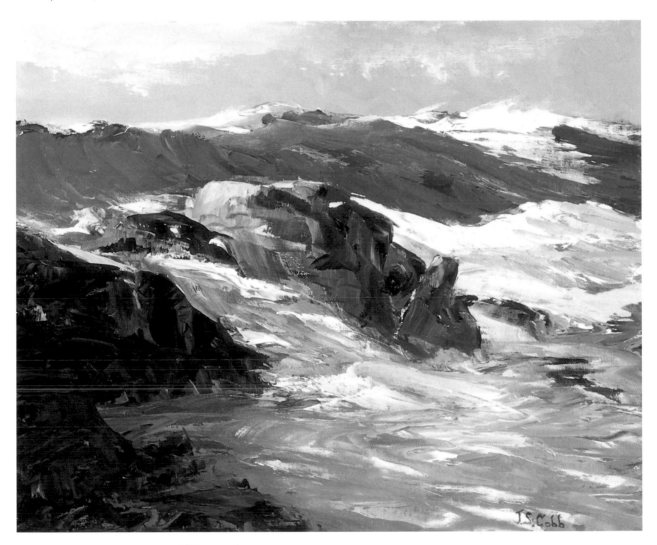

ON A PAINTING TRIP TO MONHEGAN ISLAND JUST AFTER A STORM, I came across this scene. I have always been intrigued with anything to do with the sea, particularly the ruggedness of the rocky coast line and the power of the sea as it pounds its way to the shore. Part of the challenge of painting a scene such as this was capturing that power in the continuous surging of a single wave as it builds to a climax. The cool deep gray, green, blue tone of this single wave gives it depth and motion as it swells to its peak and finally tumbles to foam. Another factor that inspired me is the way the light passes over the rocks to the breaking wave in the foreground, and finally to the outer wave with its spindrifts in the distance.

WILLIAM KAVANECK

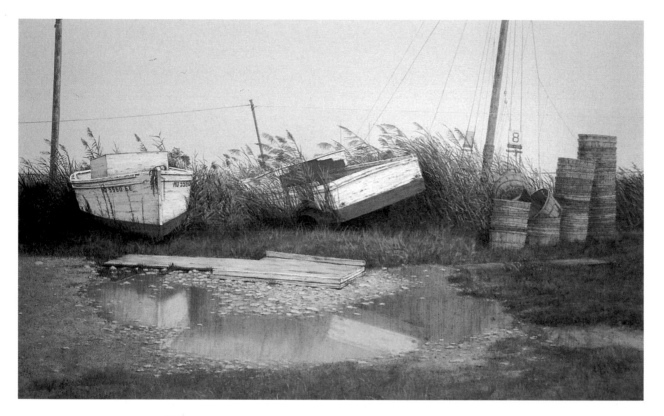

THIS PAINTING SHOULD STRIKE A CHORD WITH ANYONE WHO
has visited an elderly person's home and seen the pride and contentment resulting
from a long life of work and achievement. When old workhorses could pull
or carry no more, they were literally put out to pasture for the rest of their days.
The old "working girls" in the painting are in that category. They have given their all in calm
and rough seas, good and bad weather, morning and night. Now they sit at Tilghman Island,
Maryland, finally at rest.

On the Mud, 1995

8 x 10 inches, Oil

ANTHONY R. THOMPSON

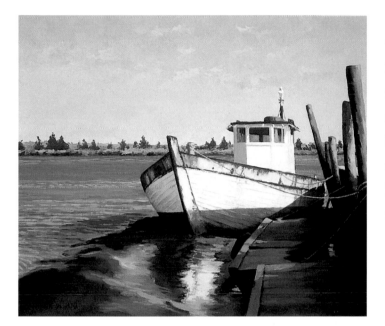

I DO NOT KNOW HER NAME. She lies in a small creek off the Maurice River in Bivalve, New Jersey several miles up from the Delaware Bay where she once worked the oyster beds. No longer active, nudged only by the tides, she is a monument to the once thriving oyster industry. I find her irresistible at low tide as she sits on the mud, gathering rust and a certain derelict charm.

JOHN ATWATER

Fog Bank Off the Hypocrites, 1996

11¼ x 24 inches, Alkyd

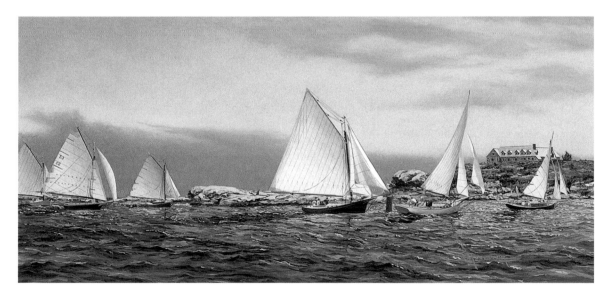

*T*HIS PAINTING DEPICTS THE ANNUAL FRIENDSHIP SLOOP RACES which are held outside Boothbay Harbor, Maine. The boats are sailing north, the rock outcroppings which make up the Hypocrites are to their port. In the distance, one may see a former religious retreat, now a private residence, on Fisherman's Island.

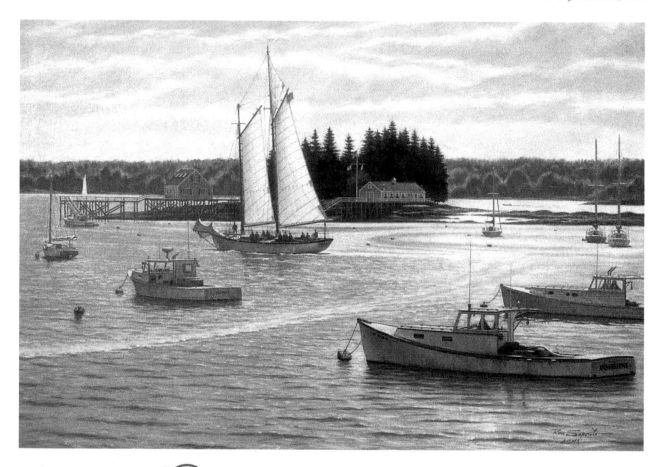

ON A BRIGHT SEPTEMBER AFTERNOON WHILE VACATIONING in Maine, I saw the schooner *Appledore* leaving Boothbay Harbor. Inspired by the glistening patterns of light that silhouetted the boats in the harbor, I made several pencil sketches, hoping to capture the effects of those fleeting moments. As I recreated the painting on canvas, I was taken back to those "September Days at Boothbay Harbor."

FRANK W. HANDLEN

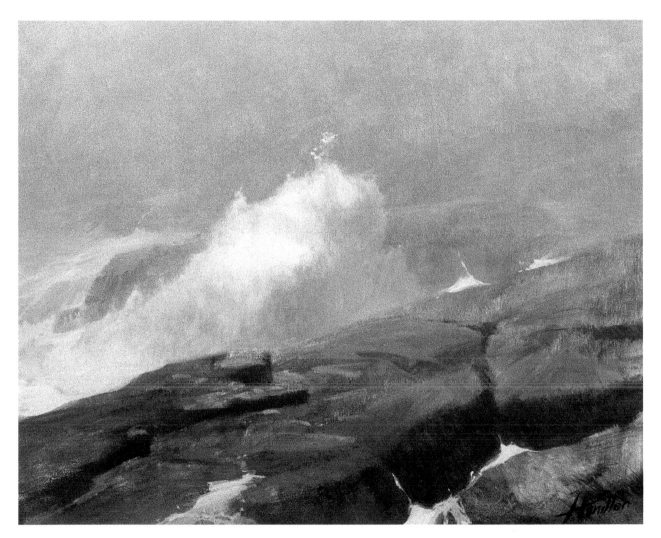

IN THIS PAINTING, IT WAS MY AVOWED PURPOSE TO RENDER the visual mystery of sea, rocks and fog. I wanted to catch the seas coming in out of a nothingness, in regained definition, and bursting in a chastened, greenish white, their shattered masses backpouring in the dark fissures of wet rocks: rhythmic, eternal, mysterious.

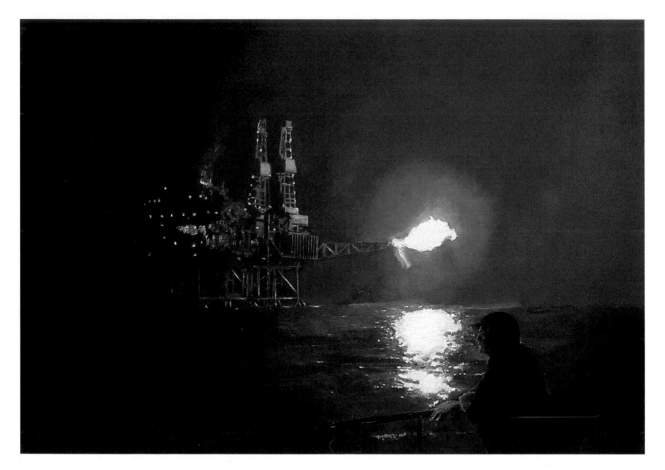

THIS IS THE PIPER ALPHA OIL PLATFORM, EAST OF ABERDEEN,
Scotland in the North Sea. I was part of a diving team that lived and worked from
a semisubmersible drilling rig anchored next to Piper Alpha that served as
a saturation diving platform. We saw the flare stack that is visible here catch fire several times
from a gas leak and then gradually melt and fall into the sea. I don't recall that we were alarmed;
probably we were just amused as we watched black smoke curl over the platform, because we
expected things to go wrong. And in 1987 they did, and it was final and terrible. Imagine
a square city block of twenty-five story buildings. From another gas leak, followed by an
explosion, two-thirds of the platform burned and melted and disappeared into the sea, taking
over 160 persons with it. Within a few minutes only a third of the platform with the two drill
towers remained above water.

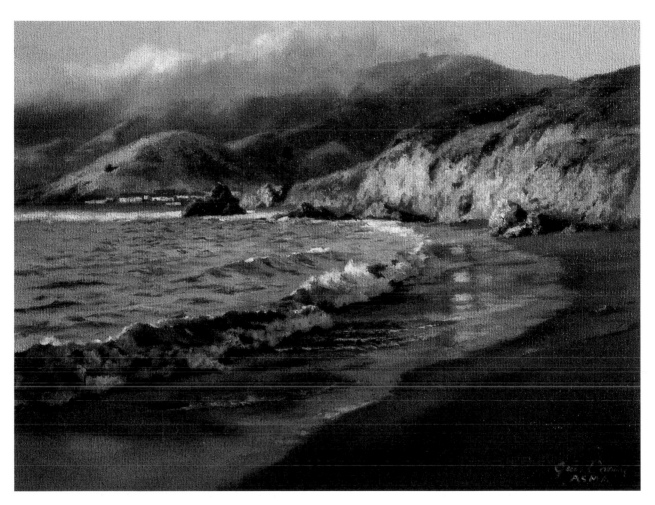

THIS PAINTING WAS INSPIRED BY A RECENT TRIP MY ARTIST husband, Dave Thimgan, and I took to the Golden Gate National Recreation Area on San Francisco Bay. I discovered this beautiful little beach just before sundown: the light on the fog rolling in was perfect. This area recently came under the jurisdiction of the National Park Service and the many forts, barracks, and batteries are still there for exploration. This area is so ruggedly beautiful that I can only begin to attempt to capture it in painting. I plan to drag Dave back down there as soon as I can.

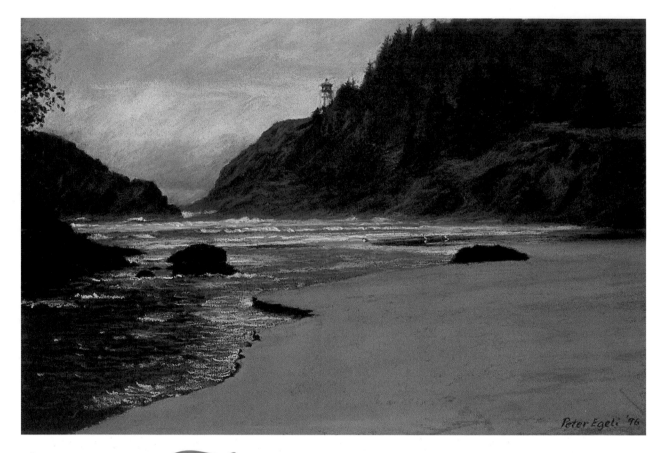

Peter Egeli '76

P ASTEL IS A WONDERFULLY EXPRESSIVE AND OFTEN
overlooked medium, useful for a wide range of subjects and capable of delivering
the most delicate nuances of light and color. It was my medium of choice for
making this essentially tonal painting of a light house on the Oregon coast.

I visited this grand place while on a vacation trip with my family and will never forget
the sense of subdued confrontation with elemental powers that permeated the atmosphere.

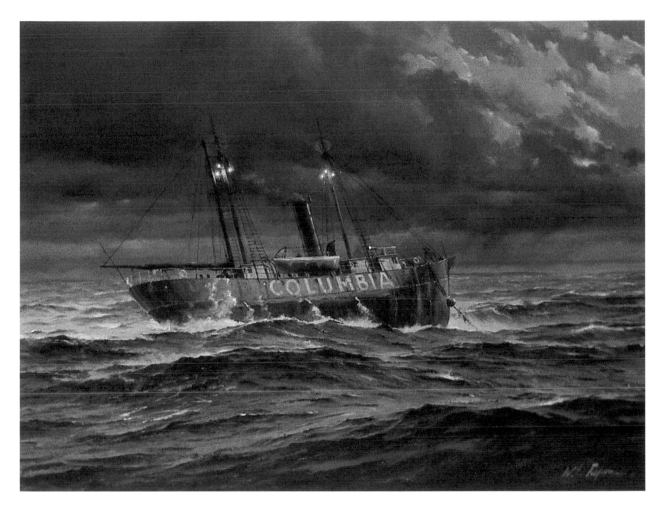

BUILT IN QUINCY MASSACHUSETTS IN 1908, THE *COLUMBIA River No. 88* did yeoman service. Stationed off the entrance to the Columbia River, the ship took some terrible beatings in storms and on several occasions picked up survivors from shipwrecks. Primarily serving at the Columbia post until 1939, she was reclassified by the Coast Guard as *No. 513* and sent to Umatilla Reef to finish her service days as a relief vessel. Acquired by the Columbia River Maritime Museum, *No. 88* was eventually sold due to financial problems.

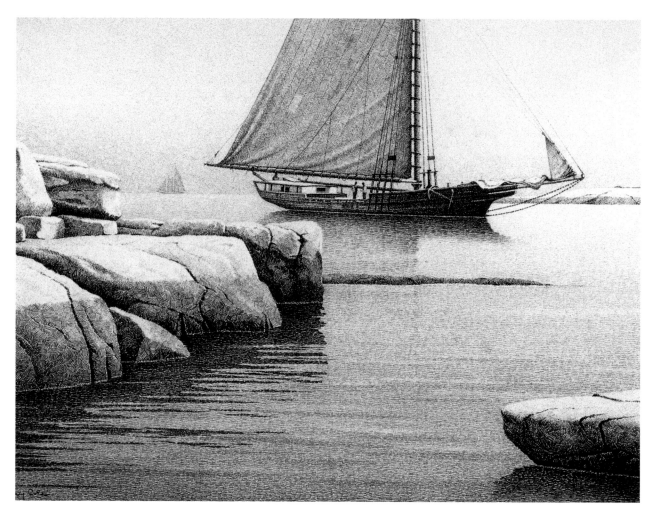

THE *WASP* WAS ONE OF A SMALL FLEET OF SLOOPS AND
schooners that carried fine pink granite from the stone quarries of Stony Creek,
Connecticut to construction sites all over the northeast. Some of the more famous
sites were the Brooklyn Bridge, Boston Railroad Station, and the base for the Statue of Liberty.
This sloop shows some of the distinctive features of vessels employed in the stone hauling
business. A derrick boom (seen on deck) and the stack for a steam powered hoister (near the
mast) were used to transfer the heavy cargo. Other features are heavier than normal rigging for
the mast and bulwarks that have been cut down to ease the loading of stone.

This drawing shows the *Wasp* returning to Stony Creek on a hazy summer day in light
air. She is passing Smith Island, one of the many Thimble Islands that cover the area off the shore
of Stony Creek. These island outcroppings are the same pink granite that is quarried on shore.

Ice Cream Cone with a View, 1995 ————————————— MARSHALL LYSANDER JOHNSON

27 x 47 inches, Oil

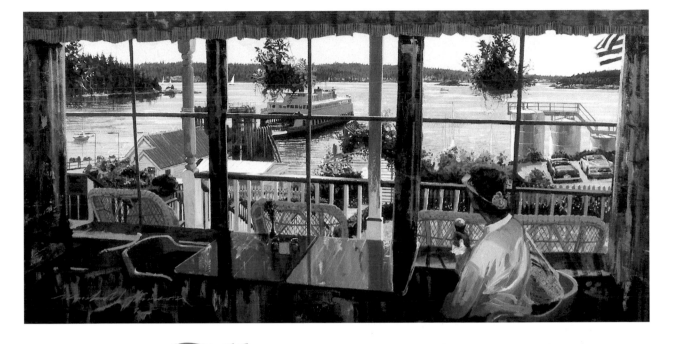

ARRIVING AT ORCAS ISLAND, A WASHINGTON STATE FERRY
picks up passengers bound for Shaw Island, Lopez Island and the ferry
terminal in Anacortes. As she waits for the westbound ferry to Friday Harbor
on San Juan Island, this tourist enjoys the view along with her ice cream cone. She's sitting
in the cafe located in the historic Orcas Hotel. Built in 1904, it sits on a hilltop above the ferry
landing. This hotel has the honor of being on the National Register of Historic Places.